The Bored @ Work Doodle Book

Thank you: miss boakes, roland, the family, ed and gizmo, parker and lamy, chester floyd carlson and you

THIS IS A CARLTON BOOK

Published by Carlton Books
20 Mortimer Street
London W1T 3JW

Artwork and Text © 2008 Ross Adams
Design © 2008 Carlton Books Limited

ISBN 978-1-84732-080-3

10 9 8 7 6 5 4 3 2

Printed in Dubai

The Bored @ Work Doodle Book

For cube monkeys, desk jockeys and salary slaves
with time on their hands

Rose Adders

CARLTON
BOOKS

Draw in this book

Colour in the images

Fill in the drawings

Stick things in it

Fill the pages with data

Cover the pages in something more
interesting

It's your book . . . use it!

Getting to know you

MY NAME IS:

BUT THEY CALL ME:

I WORK AS A:

FOR:

WITH:

I LIKE MY JOB BECAUSE:

I LOOK LIKE THIS:

MY FACE AT WORK:

MY FACE AFTER WORK:

I WANT TO GET BETTER AT:

Load your gun with highlighter ink and defend the office from hostile takeover

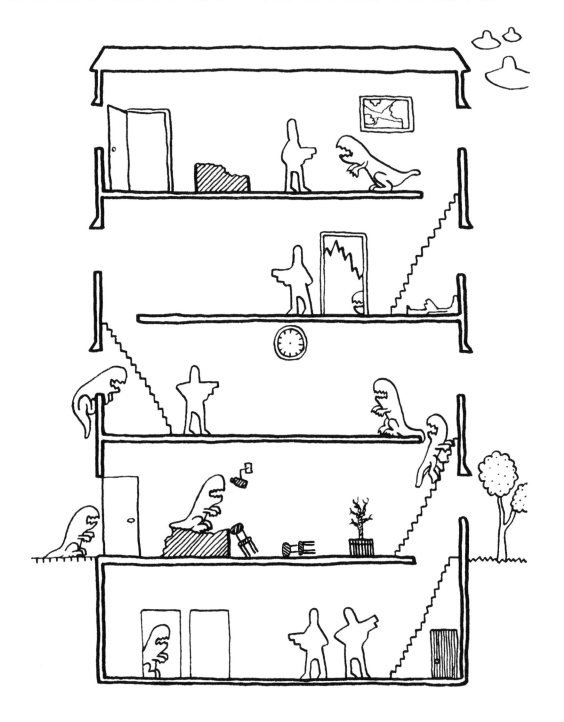

Rate your job satisfaction

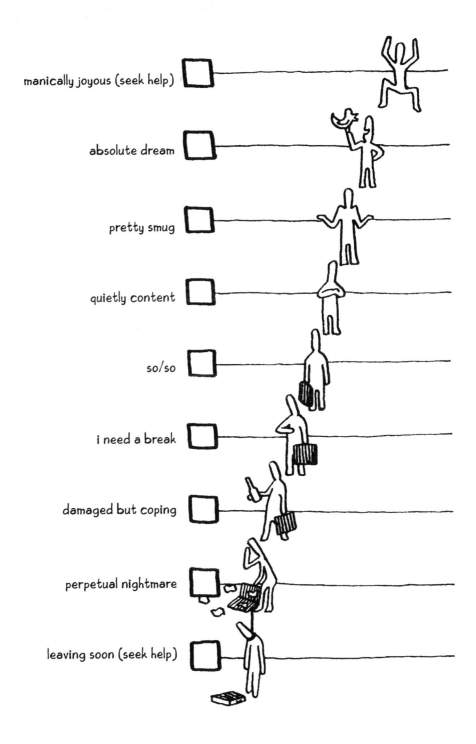

manically joyous (seek help) ☐

absolute dream ☐

pretty smug ☐

quietly content ☐

so/so ☐

i need a break ☐

damaged but coping ☐

perpetual nightmare ☐

leaving soon (seek help) ☐

What else can you sweep under the carpet?

(At the end of the day...) Turn off the lights and leave...

Reinterpret the nearest piece of office art

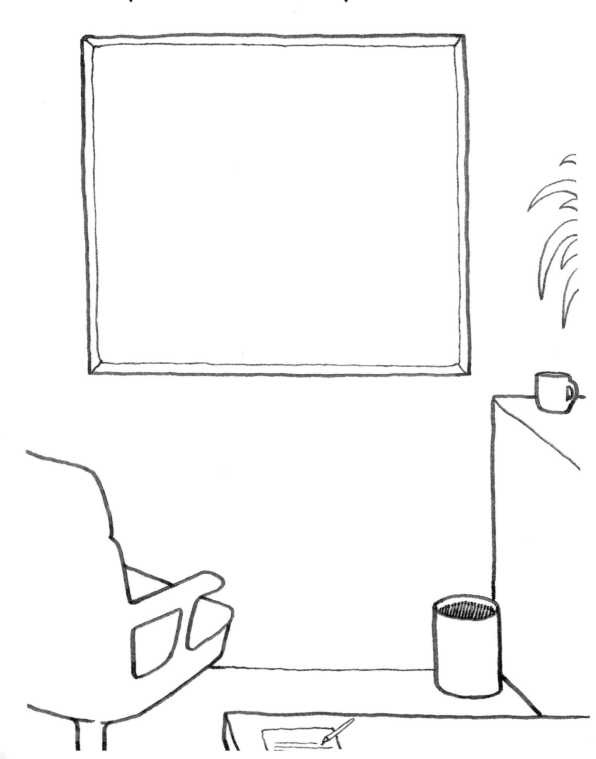

Give these noses an appropriate colour

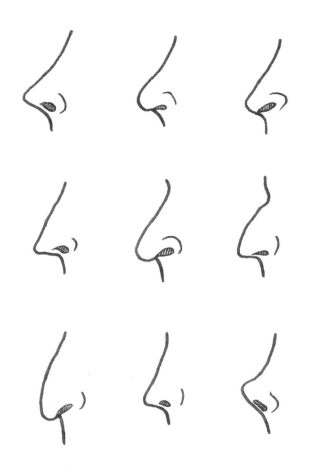

Career snakes and ladders

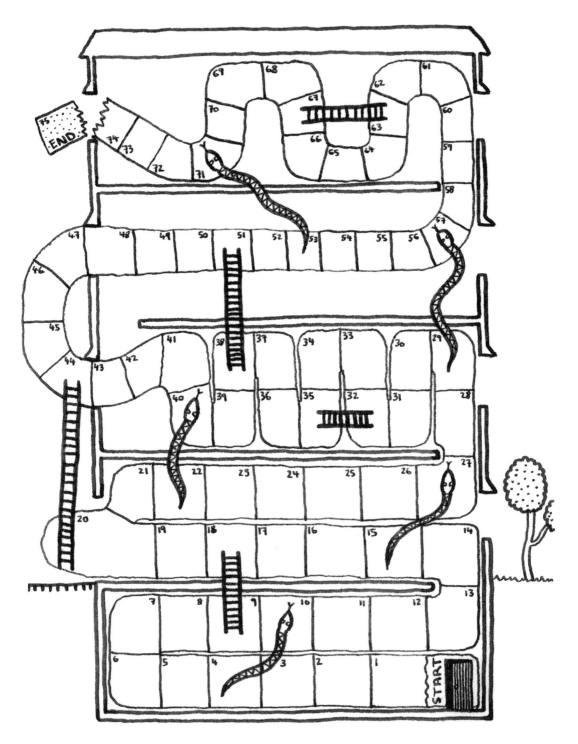

Start a fire and evacuate everyone

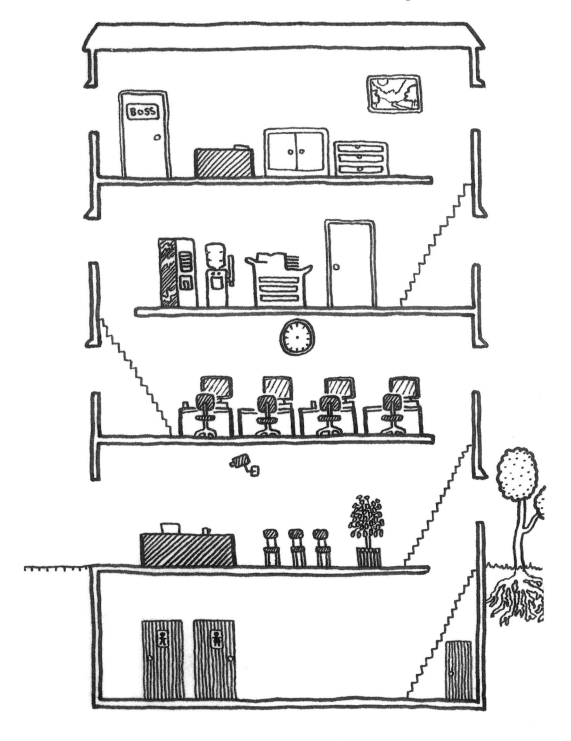

How full is your cup?

bottomless (seek help) ☐

brimming ☐

plenty left ☐

couple of gulps ☐

realistic - mid-range ☐

few sips ☐

dregs ☐

kettle on ☐

what cup? (seek help) ☐

Draw some more interesting learning curves

Dress your co-workers for the weekend

Write the inside of your own leaving card

*Sorry to hear
that you are leaving.*

Draw the team dogsbodies

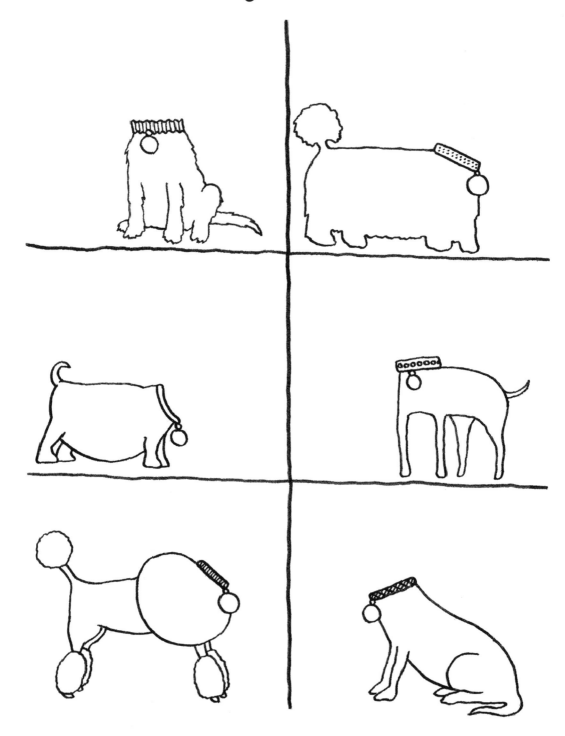

Make a mug-ring galaxy

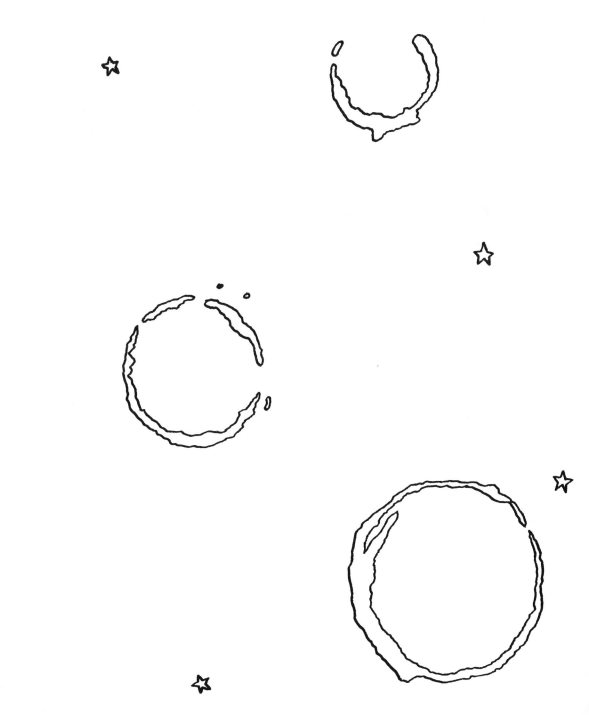

Do some proper cherry picking

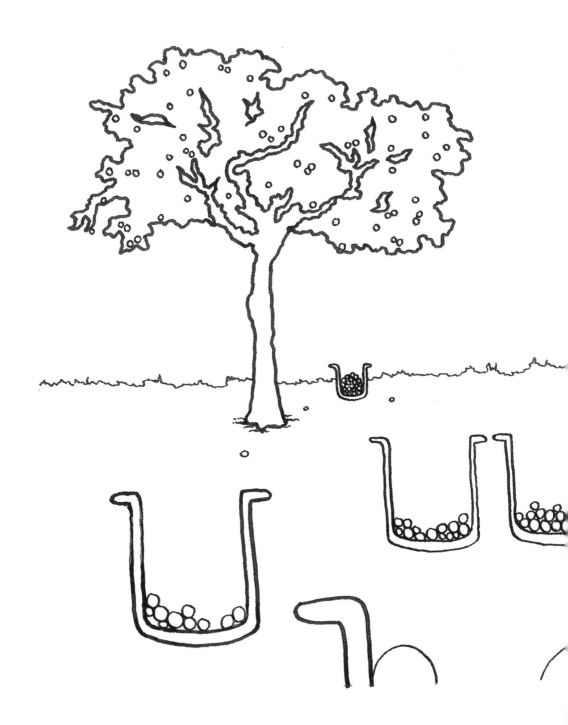

Award three points for first place, two for second and one for third

	WORKER A	WORKER B	WORKER C	WORKER D	WORKER E	WORKER F	WORKER G
MOST PUNCTUAL							
MOST PRESENTABLE							
MOST ORGANISED							
MOST MOTIVATED							
MOST CARING							
MOST POSITIVE							
MOST HELPFUL							
MOST HUMOUROUS							
MOST HARD-WORKING							
MOST GENEROUS							
MOST INTELLIGENT							
MOST DIRECT							
MOST CREATIVE							
MOST FLEXIBLE							
MOST PERSUASIVE							
MOST DEMOCRATIC							
MOST ARTICULATE							
MOST COMMITTED							
TOTAL POINTS							

YOUR STAFF AWARDS

Executive decision maker: close your eyes and let your pen guide you

Make your own money

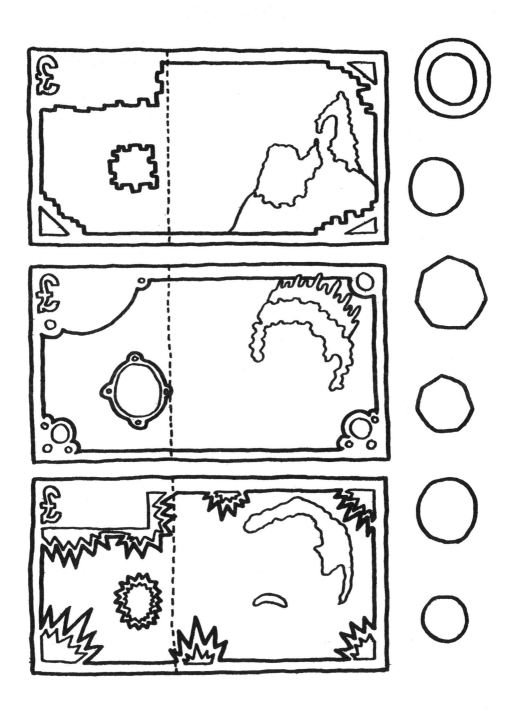

Fill in your expanding job description balloon

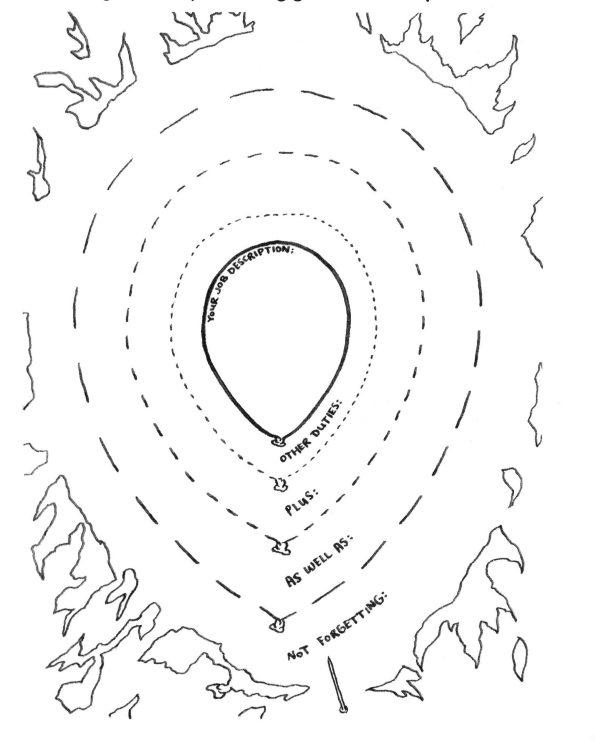

See your week in pies: one slice = one hour

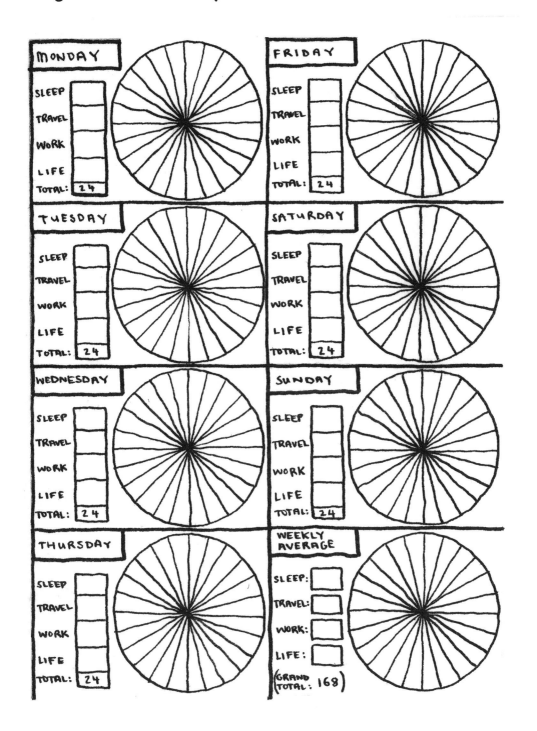

Brainstorm on this page

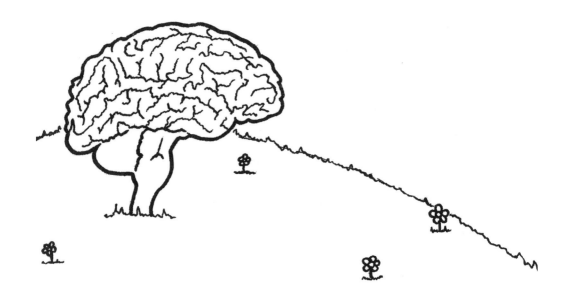

Design a fortnight of wacky ties

week 1:

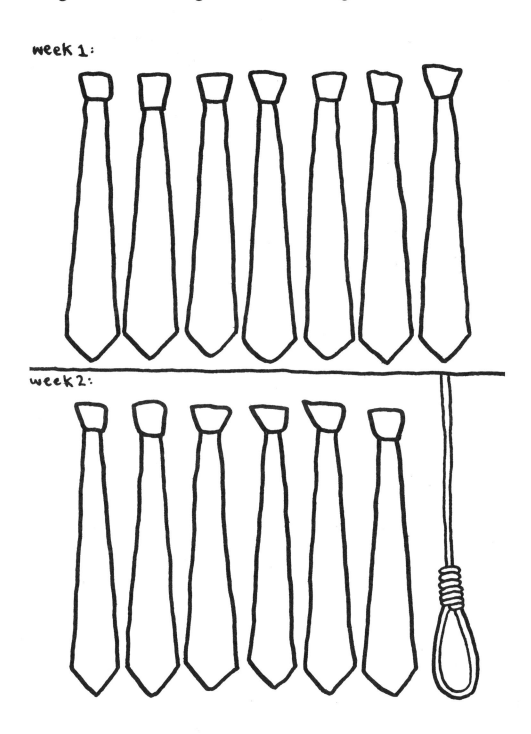

week 2:

What's left after you have liquidated all your assets?

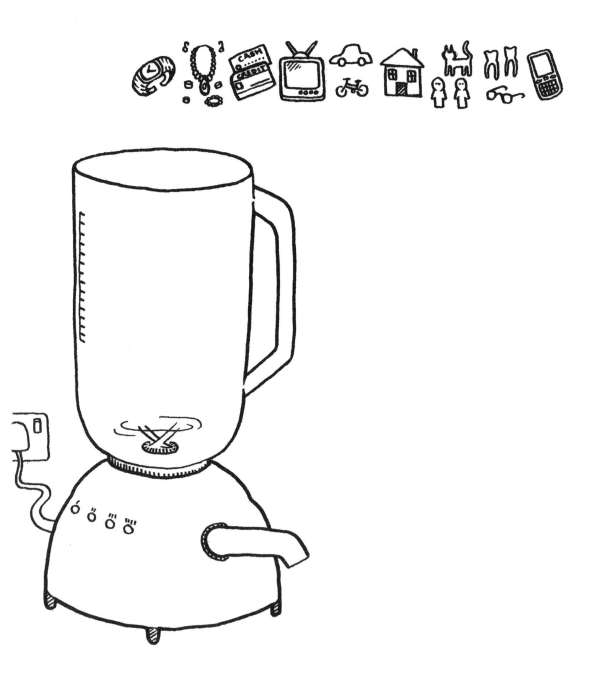

Who won the rat race?

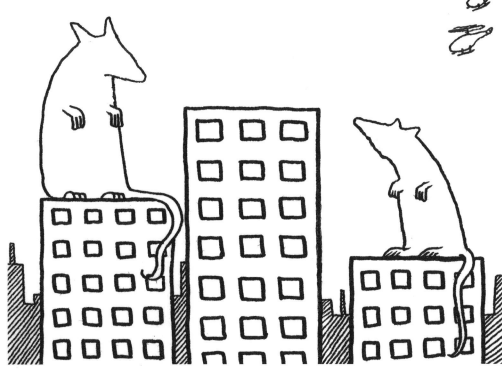

OMG who's lunchbox is this?

Draw some bubbles in the watercooler

Add some bullet points

Voodoo co-workers - do your worst

What is rolling downhill?

Fill the team's trophy cabinet

What thoughts are really outside the box?

Draw in the middleman

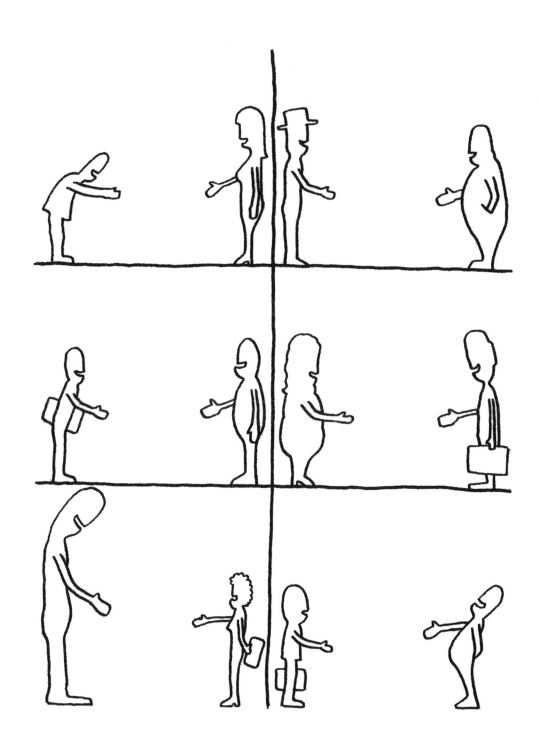

What messages would you like to get?

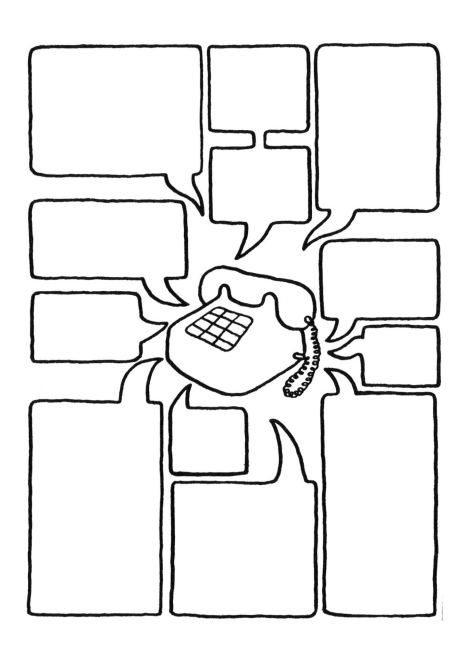

Cut-out-and-keep Carriage Clock

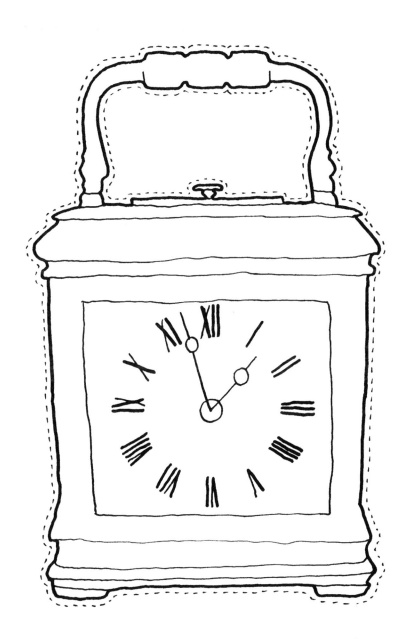

Bail your team out ... but mind what they land on

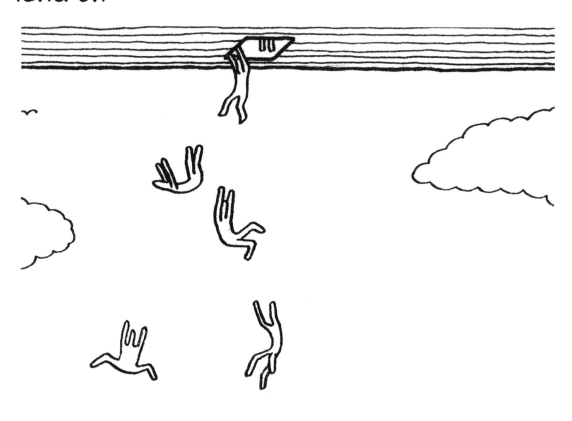

Design more bugs for your computer

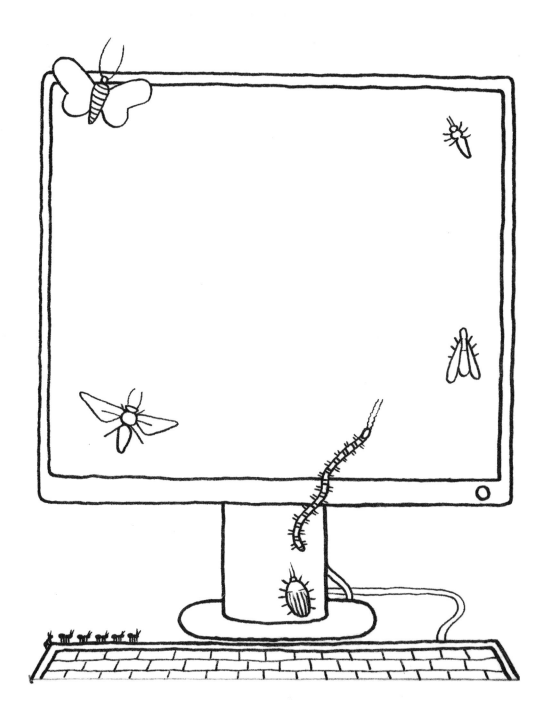

Whats at the end of the line you are towing?

Lace up and reboot your computer

Draw as many health and safety violations as possible

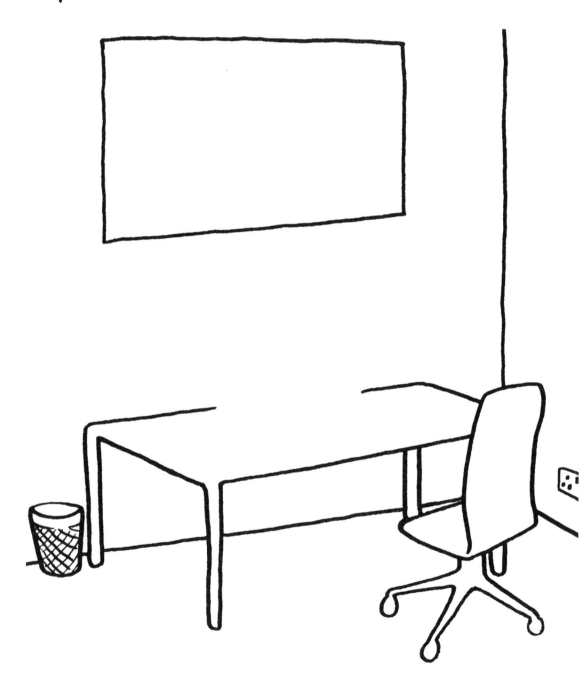

Junk mail wall of fame

✉ _____

✉ _____

✉ _____

✉ _____

✉ _____

✉ _____

✉ _____

✉ _____

Draw your ultimate office party

What's stopping you from getting the sack?

Lay your big idea on the table

What happens when you get fired?

Who would you employ? complete each applicant's picture and tick to accept them

Draw what you can see out of the nearest office window

What does your slice of the cake look like?

It's rush hour: how many bodies can you cram in each mode of transport?

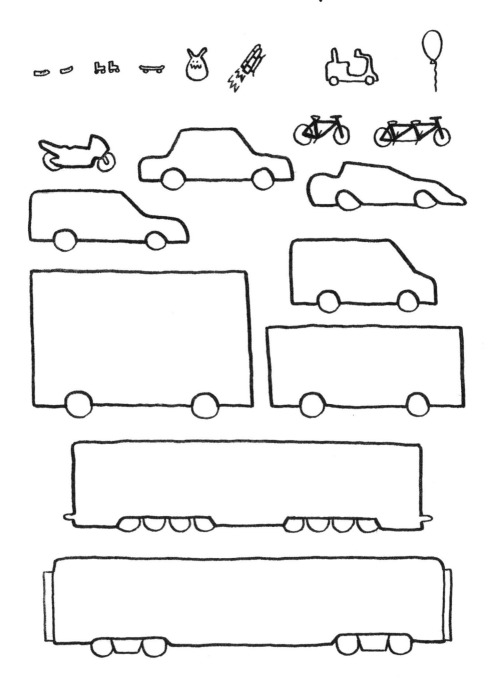

Draw what you would like to see out of the nearest office window

Rate your enjoyment of each day and plot your Happy Graph

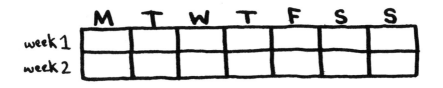

Make both ends meet

Complete the detail on these biscuits

Mark off each day on your prison wall year planner

Are the mice eating the big cheese?

Please complete the bored @ work diagnosis sheet

DATA COMA (i am in a) ☐

DUVET COMMITMENTS (i have periodic) ☐

OBJECT MISUSE (regular patterns of) ☐

NUTRITION DIVERSIONS (i take) ☐

TELEPHONIC ALLERGIES (i experience) ☐

STRESS FRACTURES (i have multiple) ☐

BOTTOMLESS INBOX (i have a) ☐

MALIGNANT MANAGEMENT (a case of) ☐

KEYBOARD BOXING (i train in) ☐

CONCENTRATION LAPSE (....look! a pen!) ☐

FOGHORN THROAT (i suffer from) ☐

GHOST TEAM (i am surrounded by a) ☐

TECHNICAL HITCHES (i am covered in) ☐

EXPECTATION CEILING (i have reached my) ☐

PRINTER MAGNETISM (i have daily) ☐

OPTION PARALYSIS (i have) ☐

"UNOFFICIAL RESEARCH" (i conduct) ☐

FLAPPING MOUTH (i have bouts of) ☐

WINDOW FIXATING (i find myself) ☐

OVERWORKED (i am) ☐

UNDERPAID (i am) ☐

Which automated device is Dave caught in?

What's happened to Dave?

Groundhog Day: make each day different

What would happen if the cleaner didn't come in for a year?

You decide what is on each floor

Complete the cycle of illness

Make a chessboard on the ceiling tiles

Who's in charge of all the honey that the worker bees have made?

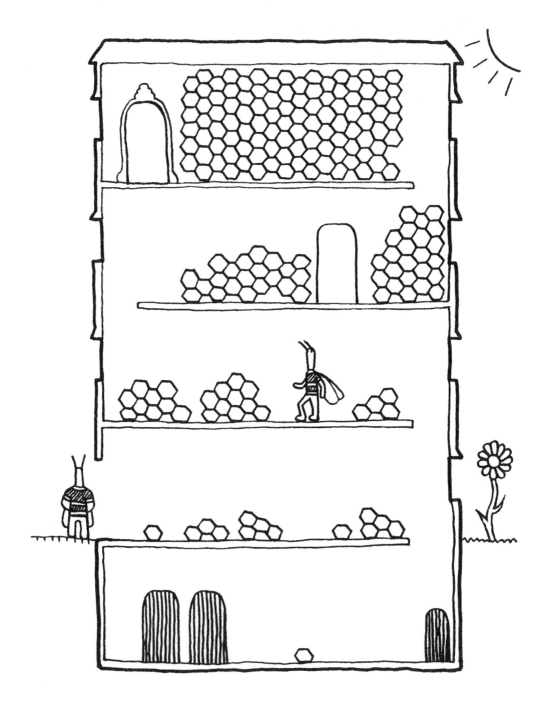

Defend your desk from invasion

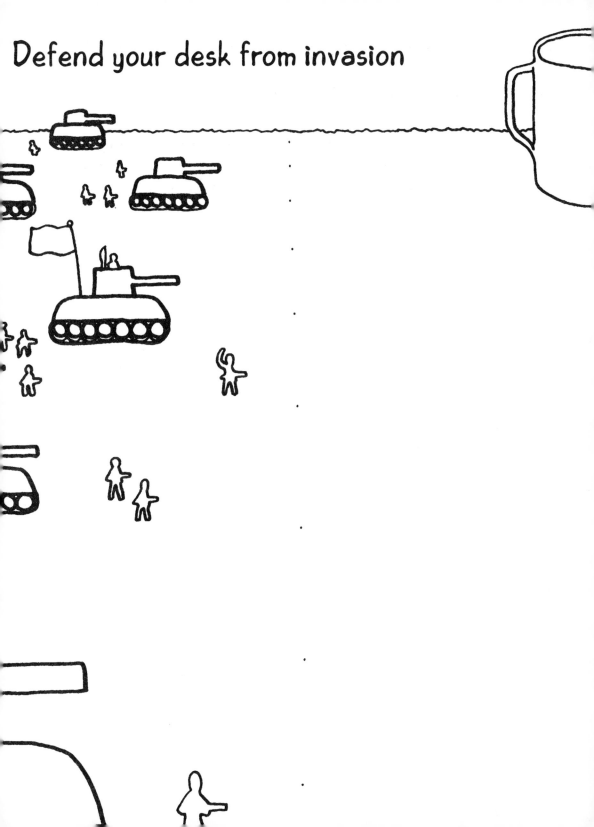

What has been left for you in reception?

Accountability: point the finger of blame

Who made your printer jam?

Keep yourself busy - fill your in and out trays

What grows in the office?

Go with the flow

Paint your nails

Give your resignation presentation

Add some rungs to the career ladders

How do you look after number one?

Avoid the bulls____, brand the cashcows and escape on the gravy train

Your notes

Do your own photocopying!

How can you adapt to the desk job?

Who exactly is in the same boat as you?
Where is everyone else?

What's inside the work bags, and who do they belong to?

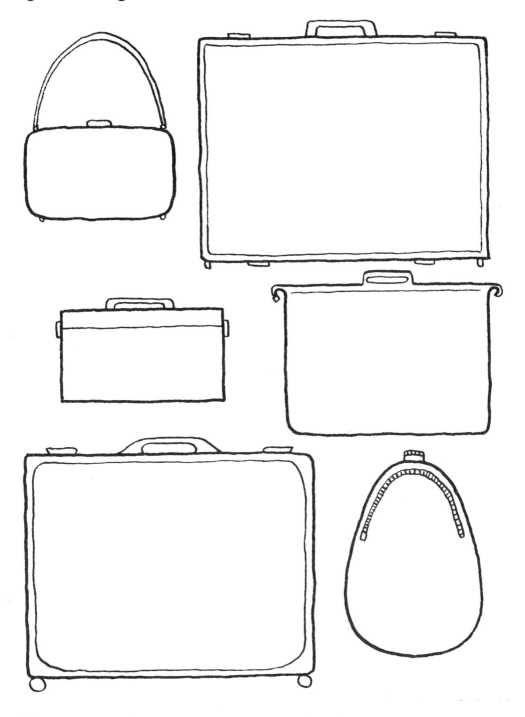

Are all your cheques in the post?

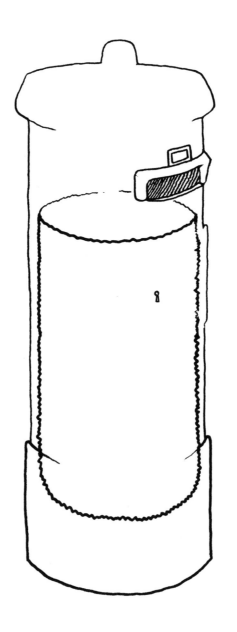

Draw your own motivational poster

SUCCESS

Discredit your colleague,
and you will shine.

Know the competition/know yourself

	🎂 BIRTHDAY	🐱 LOVED ONES	💡 INTERESTS	⭐ MY RATING
WORKER A:				
WORKER B:				
WORKER C:				
WORKER D:				
WORKER E:				
WORKER F:				
WORKER G:				

What can you see in the chad storm?

Who has been shipwrecked?

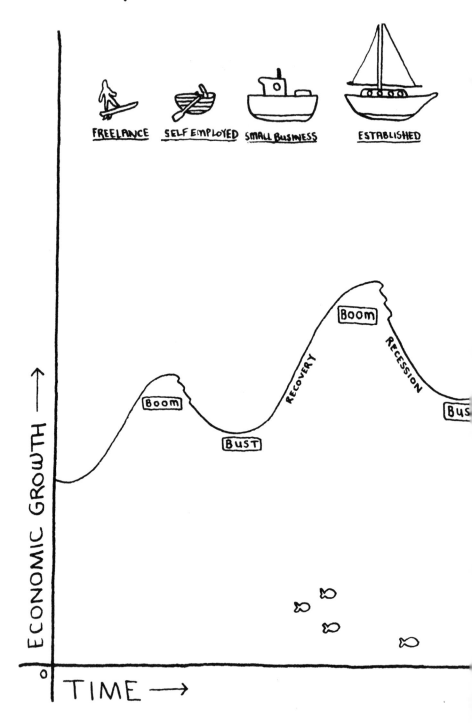

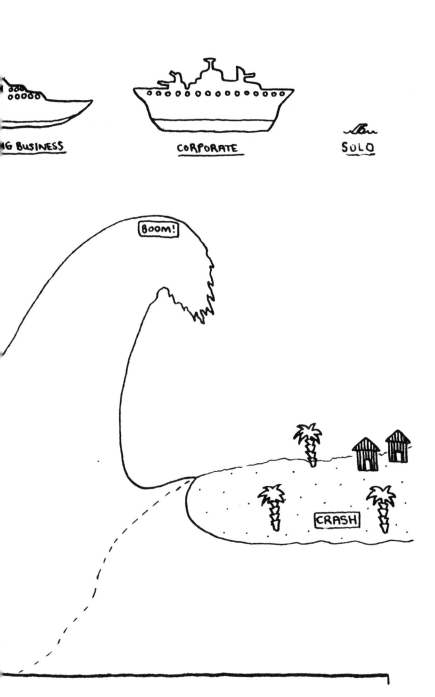

Make these workers tear their hair out

Add to these office viewpoints

(corridor, desk, keyboard, clock)

Where are you in the field of employment?

FOLDED

OFFICIAL COMPLAINT

REDUNDANCY

FIRED

DISCIPLINARY

RED TAPE

STRESS

RETIRED

RESIGNATION

FIRED

DEBT

LEISURE

PANIC

Certificate of Completion
Awarded to

For outstanding contributions to the
Bored @ Work Doodle Book

You have excelled in the following areas:

_____ and _____

These skills will serve you well.
Good Work.

SIGNED _Rose Adders_____

DATE _____